# Foreword

The arts are the first language of young children—their way of responding to the world around them. Babies coo and imitate their mothers' singing of lullabies; and scribbling is a normal part of every child's early development. Young children are naturally inquisitive and imaginative. They love to sing, paint, dance, and play. They are not afraid to ask questions and frequently invent stories that represent their own view of the world.

Making art helps children learn to look at the world around them and think in new and different ways. Unlike most subjects in school that usually have only one correct answer—art has an endless number of "right answers." In schools with quality arts education programs, students learn teamwork and how to solve problems creatively. They are actively involved and excited about learning; as a result, they are more likely to come to school and stay in school.

We know that creating a positive learning environment and keeping students in school are both very important. But more significant is the value the arts bring to us as human beings. Every ancient civilization known today has left behind artifacts that tell us about those cultures and how they lived. The arts help us understand who we are and where we have been.

As you look through the pages of this delightful book, you will discover that innovation and creativity abound. It is exciting to see how children view their future and express themselves through the medium of art.

**Bonnie B. Rushlow, Ed.D.**
**President**
**National Art Education Association**
**Reston, Virginia**

# Children's Visions of the Future

## 2007 - 2008 JURIED ART EXHIBITION

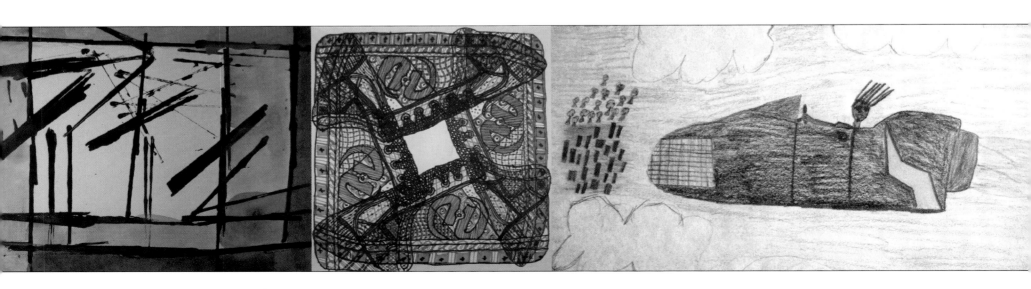

## Children's Visions of the Future

Published by

Crayola LLC

1100 Church Lane

Easton, PA 18044-0431

www.crayola.com

Book and Cover Design

Suzanne Burke

Editorial Production

Susan L. Williams

Printed and bound in the United States of America by Kutztown Publishing Co., Inc.
Kutztown, Pennsylvania

ISBN 978-0-86696-330-5

# Table of Contents

# Welcome

How well I remember the first time I entered the Crayola factory in Easton, Pennsylvania. I had expected to be overwhelmed by gargantuan vats of molten pigment and Willy Wonka-like contraptions molding colored sticks and jamming them like sardines into yellow boxes. Instead, as the doors swung open, I was overwhelmed by the pungent smell—yes, smell—of untold billons of crayons. And I was instantaneously transported to my mother's kitchen table where a towheaded boy was coloring who knows what as Mom puttered about her kitchen on a rainy Saturday afternoon.

As I watch my own children now, surrounded by enough electronic stimuli to dull the brightest mind and toys that can virtually play by themselves, I am grateful for these timeless and simple gifts. And what a gift they are.

It is said that we can only give our children two things really, roots and wings. It is almost magical that a box of 64 crayons can do both.

Grasping your first crayon is no small feat for tiny fingers. It is also, indeed, a tiny rite of passage. You can feel the intense pride of a child who can finally "make their mark." And from that moment on, these hands are given a sense of control and power greater than any light saber. You see, a box of crayons invites action. It asks us to look at the world with new eyes, fresh eyes, and then to look again. To make something from nothing. As your crayon forms a sun or a tree or Mommy and

Daddy, you learn color, proportion, anatomy, relationships. And from there, quite literally, you begin to think outside the box. To imagine worlds and things and ideas that have yet to be made. Or thunk. You place yourself in the world that you create. A world in which you are invincible. You learn that the power…is in you to make something from nothing. And that what you make will be, in the end, uniquely yours. And when it goes under the magnets on the fridge, you know that your efforts are treasured. Try to do that with a video game.

And what of wings? When that day comes when we must push our children gently from the safety of the nest, they need to know that they can fly on their own. And to do that in an uncertain and ever-changing world, these little ones must believe that they carry within themselves infinite possibilities. That the blank page in front of them is just waiting for them to make their mark, that the world they create will be good. That they can soar.

And, as they soar, we watch with pride from our now-empty nests and we undoubtedly find ourselves racing to the attic, thumbing fondly through those fragile yellowed drawings of ladies in triangle skirts, cookie-cutter clouds, and matchbox houses, we will feel those days anew and, as they say, stop and smell the crayons. For they are, indeed, the art of childhood.

**Gordon Bowen**
**Chief Creative Officer**
mcgarrybowen
**New York City**

# Introduction

This lovely book offers us an invitation to see into the world of the future through children's art; a world in which the water is clean, animals are cared for, and houses can be self-cleaning!

Why do children make art? It is where they make the world of experience meaningful for themselves and to others. It is where they explore life and beauty. With crayons and paints, on paper and canvas, they think, feel and form ideas. Through the images they imagine and create, they express their hopes, dreams, fears and loves. In making art, children open themselves to their imaginations, test their ideas about the world, and make their own courageous and complex journeys in learning.

In facing the future, children in this day and age must contend with both hope and fear: hope in potential of the imagination to make technological advances that benefit everyone; fear that the social repercussions of progress might outweigh their good. Caught in between, even very young children sense the future in their present. As children learn to use materials in ever more complex ways, they invent forms and create compositions that embody their hopes, dreams and fears. We see how they think and feel and how they form ideas and make judgments.

Creating art also provides the opportunity to give unique expression to children's experiences in forms that are shared by others in their culture. As they

generate images and compositions, children form concepts and perceptions that offer them a conduit to their cultures and to the cultures of others. The many and courageous ways in which children open themselves to their imaginations, as they form their unique ideas, may be what adults admire most. As we see, the future here is portrayed in many wonderful and personal ways, from hair salons that fly, to an imagined hole digger, to worlds above danger in the sky.

If children are supported in their artistic endeavors throughout childhood, and if teachers and parents become partners to this end, artistic sensibilities are kept alive. As we see in these paintings, drawings, collages and assemblages, the practice of the visual arts offers us a window on children's worlds. Through this window, we see how they observe, investigate and imagine. Above all, we admire the way that children capture the expansiveness of life, the bravery of their ideas, and the sheer intelligence of their imaginations. As spectators to paintings and drawings made by children, we understand that they depict the "livingness" of their subjects.

This is a book about the artwork of children. It is through art that children awaken to the world, imagine, act, invent, observe, investigate, explore and make sense of the world in the present and in the future. Put simply, all children are the rulers in the lands of their imaginations.

**Judith M. Burton, Ed.D. FRSA**
**Director, Art and Art Education**
**Teachers College, Columbia University**
**New York City**

# Architecture & Design

*"The thing always happens that you really believe in; and the belief in a thing makes it happen."* — *Frank Lloyd Wright*

It has been said that architecture is the marriage of art and engineering. There have been eras when architecture and design have made great strides in improving the quality of life and aesthetics.

Today, the challenges for architects, interior designers, and landscapers are greater than ever. We need to build with sustainable materials and environmentally-friendly formats that conserve energy, increase security, and reduce the overall carbon footprint. The next generation of great architects will distinguish themselves by developing livable spaces for people while sustaining the environment. To accomplish these goals means their creative problem-solving abilities must rise to new levels.

Design permeates every aspect of our lives…from the morning news to every package we use. Visual communications are found in publishing, packaging, and advertising. New art forms are being created as electronic venues entertain and inform us. Today's students can only imagine the interactive media they will be using in their future jobs. Designers will always play a special role in society, helping others access and use the tools of the day. Innovation will guide tomorrow's architects and designers. You'll get a glimpse of the future through the eyes of these aspiring artists.

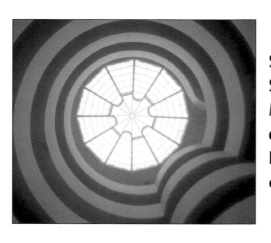

**Sloping ramp inside Solomon R. Guggenheim Museum, New York City, designed by Architect Frank Lloyd Wright, completed in 1959.**

Jacoby D.
Grade 2
CARMICHAEL ELEMENTARY SCHOOL
"My Street of Dreams"
*I think that in the future our buildings will be very tall. They will be shaped
like rectangles and ovals. They will have moving floors to get places faster.
And, they will have robots to do work for them. I think there will be grass and solar
panels on every roof. All of this will help our world be more energy efficient.*

Cole H.
Grade 1
PRESBYTERIAN CHRISTIAN SCHOOL
"The Shape Confuser"
*The shapes are doors that never end.*

Riley M.
Grade 1
SHAWSHEEN ELEMENTARY SCHOOL
"Riley's Playground Design"
Children are playing Ring-Around-the-Rosie in the back, there is a slide to the left and at the bottom is a shallow pool where they can splash into when they land. Beside the slide to the back is a tunnel, the middle is another tunnel with a button that will push you out into the pool. The blue to the right is a slide with a sun shade on top.

Madalyn W.
Grade 5
CRELLIN ELEMENTARY SCHOOL
"Family Room"
It is a futuristic family room with big soft chairs and a flat screen T.V.

"At the same time kids fill a piece of paper with color, they fill their minds with imagination and their hearts with confidence."
— Craig Yoe, Co-Founder, Yoe! Studio

Keegan G.
Grade 3
PEACE LUTHERAN SCHOOL
"The Fun Tower"
*It would be fun to be in the fun tower.*

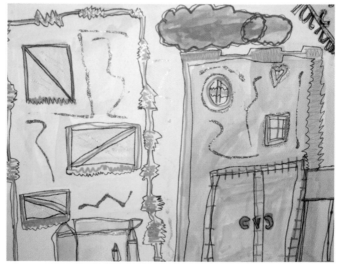

Aakriti K.
Grade 2
PEACE LUTHERAN SCHOOL
"The Wiggly Place"
*This is my dream world.*

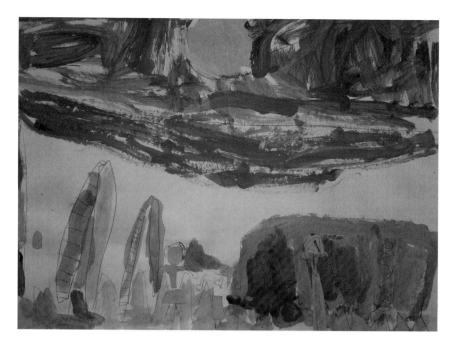

Abigail P.
Grade 1
ANTHONY WAYNE ELEMENTARY SCHOOL
"Our Future Playground"

*This is our school's new playground from the future. Me, Mom and my sister are there playing. The swings move like teeter-totters and the slides are high as the sky. In case it rains, some of the slides are indoors. There's a purple wall for climbing and that's so tall it almost touches the sky. This is a playground I imagined for the future.*

Veronica M.
Grade 6
DAYSPRING CHRISTIAN ACADEMY
"Funky Spunky Poka Dots"
*Redesigning my room.*

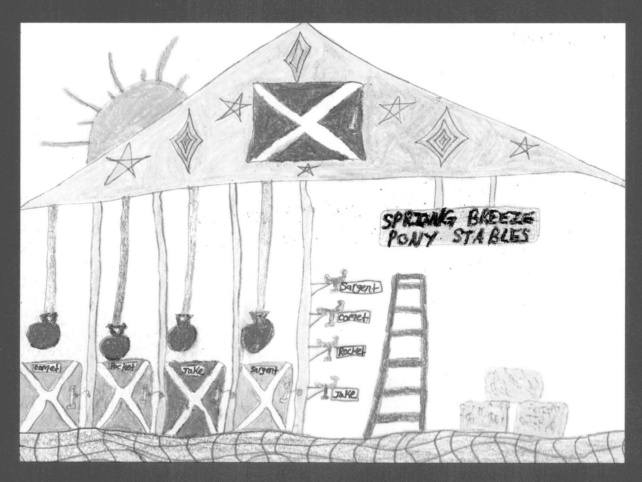

Erica K.
Grade 5
BLECKLEY COUNTY ELEMENTARY SCHOOL
"The New and Improved Barn for Miniature Ponies"
*This barn will keep your ponies smelling good and will be a perfect shelter for them.*

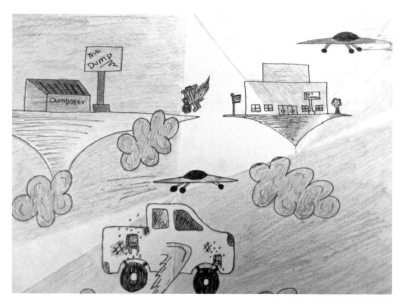

Abby C.

Grade 6

BOYS AND GIRLS CLUB MUSIC AND ARTS CENTER

"City of the Sky"

*A floating city where simple tasks are done by robots.*

Lynette I.

Grade 5

JOHN TARTAN ELEMENTARY SCHOOL

"My Dreamhouse"

*This picture is a combination of my love for architecture and baking.*
*My mom and I bake cakes together and I thought it would be fun*
*to live in a house made out of cake.*

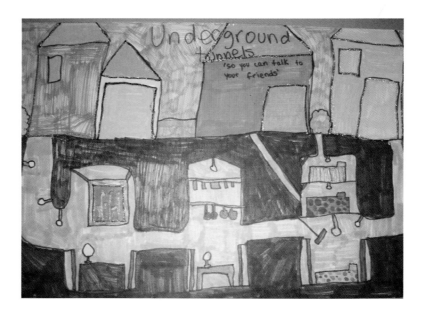

Nicole I.
Grade 5
PEACE LUTHERAN SCHOOL
"Underground Tunnels"
*You can talk to your friends underground.*

Lucy K.
Grade 2
FRIENDSHIP VALLEY ELEMENTARY SCHOOL
"My Future Happy House"
*I would feel happy because of all the colors and shapes.*
*The architecture is very beautiful and it stands out.*

Shania V.
Grade 2
GREENWOOD ELEMENTARY SCHOOL
"The City"
*I wanted to design these buildings because they reminded me of the ones
I saw when I went to New York. I saw really big buildings there,
and liked them, but I also decided to add some small buildings too.
I made some triangles, squares and rectangles with cardboard to print the
lines. I added color with the oil pastels and used blue paint for the sky.*

Devin S.

Grade 6

SUNSET CANYON ELEMENTARY SCHOOL

"Space Station"

*I wanted to design the shape of a space station.*

Sergio P.
Grade 4
LARKSPUR ELEMENTARY SCHOOL
"Arrow Windows"
*I think it was interesting to design windows in a weird shape.*

# The Arts

*"I found I could say things with color and shapes that I couldn't say any other way— things I had no words for." — Georgia O'Keeffe*

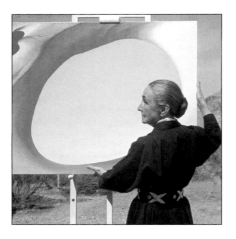

**American Artist Georgia O'Keeffe working on a piece of art in New Mexico, 1960.**

As we enter the 21st century, Americans need creativity now more than ever. At a time when children are measured by academic tests in reading, writing, mathematics and science, the arts play an increasingly important role. A holistic view of children's knowledge includes how they see the world and what innovative solutions they can generate. The arts have an enormous and important impact on human brain development. How well one memorizes rote answers and regurgitates them on a test is not the key measure of intelligence. Engaging children in the arts stimulates their curiosity and increases cognitive abilities. The arts— whether music, dance, visual expression, literary composition, or drama—develop visual-spatial abilities, reflection, self-criticism, and experimentation. Additionally, creative people are more likely to be leaders, fulfill responsibilities, be happy and successful in life.

Globally, there is an emerging awareness that creativity is a requirement for the upcoming generation. No longer can students simply memorize existing information. Tomorrow's solutions to today's problems require original thinking. Creative people generate new, novel thoughts. Nations that support cutting edge, creative thinking will be the future centers of innovation and strength. For many reasons, the arts are critical to our quality of life.

Sadie M.
Kindergarten
ISELY TRADITIONAL MAGNET ELEMENTARY SCHOOL
"Grasshopper"
*We were learning horizontal and vertical lines.*

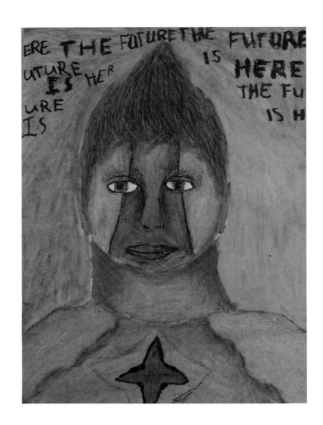

Brendan B.

Grade 6

SOUTHINGTON LOCAL SCHOOL

"The Future Is Here"

*My portrait's basic meaning is that I think the future will be filled
with a more colorful environment as well as colorful people. I think that
since we dye our hair today, who's to say that people won't dye their skin
in years from now? Also, I think the weather conditions will be harder
to withstand then they are today, so the idea for my clothing is that
it hangs kind of loose if it is hot and clings to you if it is cold, that is why
in my portrait it is tight on his skin. The design for the hair could be
anything so I went with something resembling a Mohawk.*

Ashley R.
Grade 3
HOLY FAMILY SCHOOL
"Happy Father's Day"
*I love to paint this is a portrait of me and him.
It was his father's day gift.*

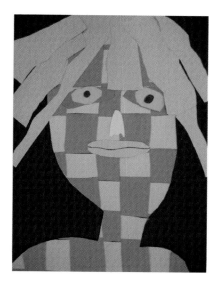

Pope N.
Grade 4
TELEGRAPH INTERMEDIATE SCHOOL
"Weaving Good Character"
*My person has big eyes so he can see all the
beautiful artwork in the world.*

Dallas Jade F.
Grade 4
BLECKLEY COUNTY ELEMENTARY SCHOOL
"Magical Mask"
*We learned how Native Americans used animal
characteristics to make masks. I used them too.*

Mariuxi R.
Grade 2
PS 170 ESTABAN VINCENTE SCHOOL
"Feeling Happy"
*This is a picture of a person that is feeling happy
with their very cool hairstyle.*

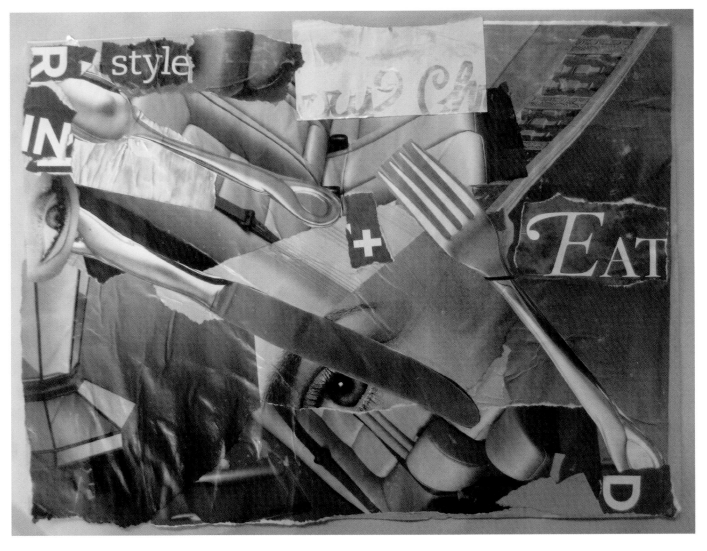

Joe J.
Grade 6
ALBERT F. BIELLA ELEMENTARY SCHOOL
"Chrome Future"
*In the future the world will be made of chrome and everything will be shiney.*

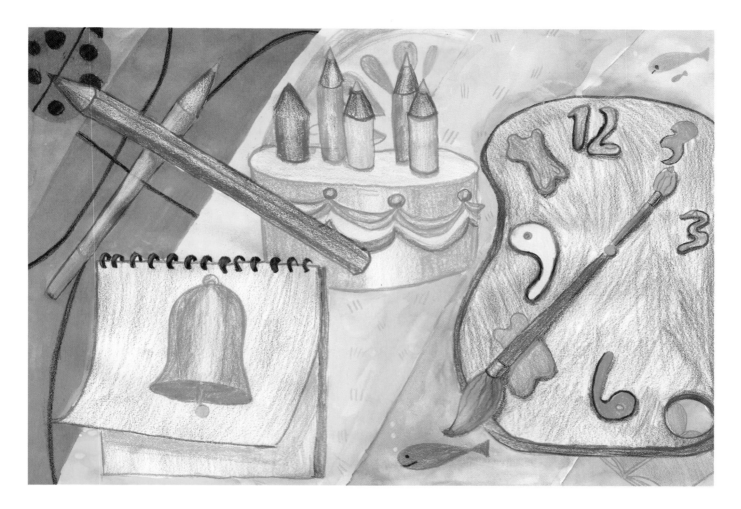

"What a wonderful world! We all learn differently and express ourselves through a variety of media and methods. Art and play remain the universal language of children." — Julia Webb Bland, Executive Director, Louisiana Children's Museum

Anisha S.

Grade 5

ECOLE-D'ART

"Art is Everywhere!"

*I drew a picture that shows everyday items are touched by art in different ways.*

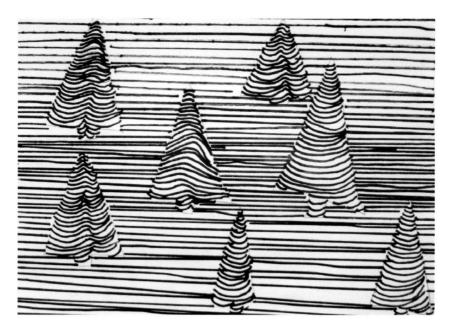

Erin H.
Grade 3
ARENDELL PARROTT ACADEMY
"Pines in Lines"
*We used line and design to create a space warp effect.*

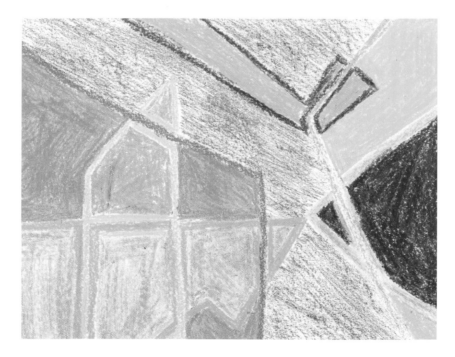

Emily H.
Grade 6
PRESBYTERIAN CHRISTIAN SCHOOL
"Art From The Heart"
*Art is a way to express yourself without words. With all the bright colors*
*and strange shapes. I feel like I expressed the joy of living in God's gorgeous creation.*

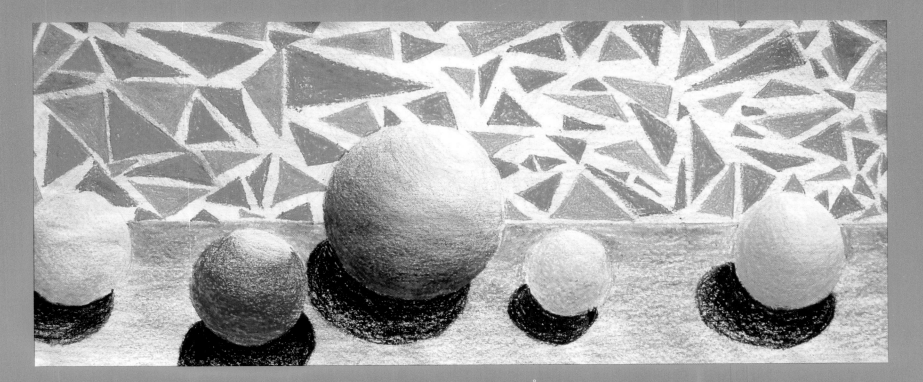

Lauren J.
Grade 5
ARENDELL PARROTT ACADEMY
"Spheres and Triangles"
*I used warm and cool colors and the image of the ocean for the floor.*

Nathan S.
Grade 1
PEACE LUTHERAN SCHOOL
"Vincent van Gogh Flying Through a Starry Night"
*I wish I could fly in a plane with Vincent van Gogh on a starry night.*

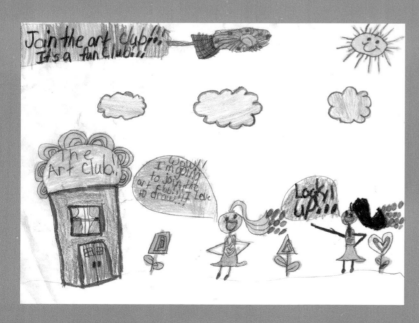

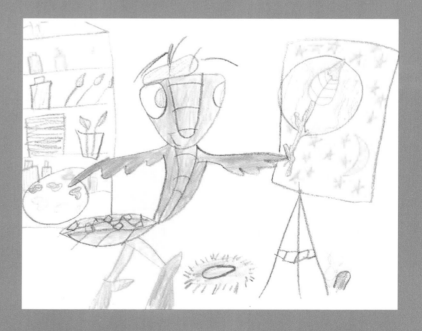

Riquana W.
Grade 4
CLARKSVILLE ELEMENTARY SCHOOL
"The New World"
*I think everyone should join an art club.*

Jeremy R.
Grade 1
TOLIVER ELEMENTARY SCHOOL
"Anyone can Paint"
*An Artist can come from anywhere.*

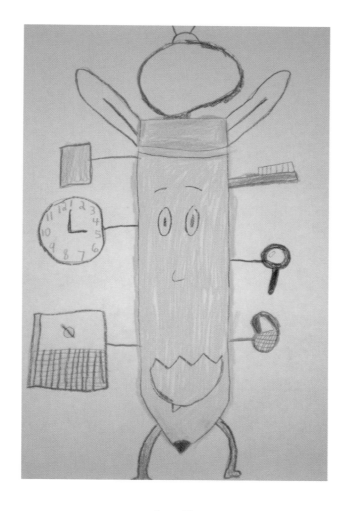

Ava R.

Grade 4

"Pencilmania"

*I made a futuristic pencil. It has a hammer, clock, laptop, toothbrush, magnifying glass and a cell phone. Also, it has wings and a t.v. on the top. Its eyes can see questions so its mouth can tell you answers. Its legs can run up to 3mph. It does not need to draw on paper as it can draw anything in midair.*
*Anything that it draws comes to life.*

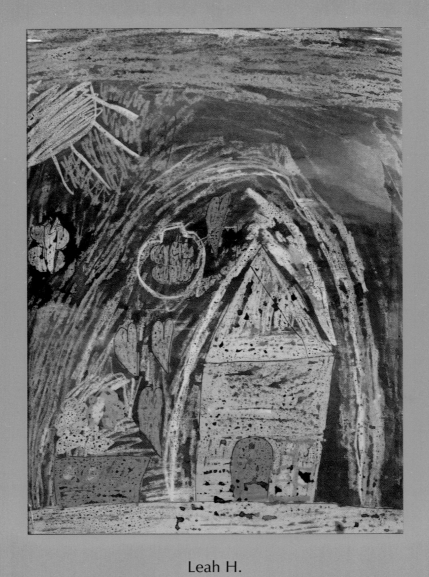

Leah H.
Grade 2
BARNARD SCHOOL
"Rainbow House"
*Artists can change the world by making new stuff.*

Crayola  *The Arts*

Natalie C.
Grade 1
LEXINGTON ELEMENTARY SCHOOL
"My World"
*I always see lots of colors and shapes in my world.*

Ashlyn C.
Grade 3
LEXINGTON ELEMENTARY SCHOOL
"Dreamland"
*Where imaginations become designs. You dream it and it's there.*

Chand P.
Grade 3
ERNEST J. FINIZIO-ALDENE SCHOOL
"The Funky Hand Patterns"
*My artwork has hands painted with colors and designs.*

Ashly P.
Grade 2
SHERMAN ELEMENTARY SCHOOL
"Future Magic"
*My art has almost all the colors in the world. It also has some shapes. My art even has stripes!*

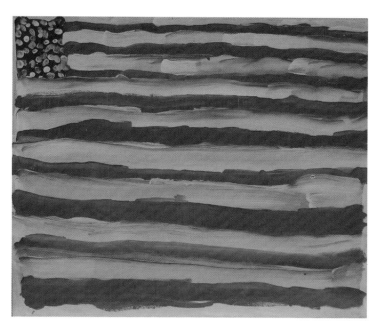

Dakotah O.

Grade 4

LAKE RIDGE MIDDLE SCHOOL

"America The Beautiful"

*America is free. American is beautiful. The American Flag is the best piece of art.*

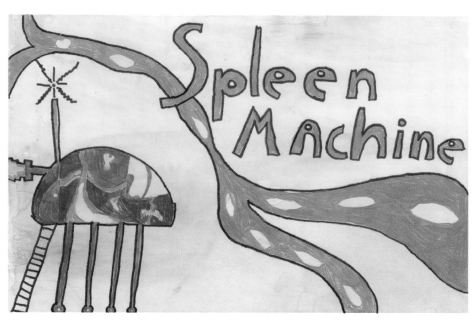

Kyle G.

Grade 4

MAMIE P. WHITESIDES ELEMENTARY SCHOOL

"The Spleen Machine"

*Advances in medicine made possible by art.*

# Environment

*"The power of imagination makes us infinite."* — *John Muir*

Creativity can be a significant catalyst for change. In our 21st century world, information has become a commodity as important as goods and services. Pollution, dependency on fossil fuels, and global warming are reminders that ingenious thinkers and problem solvers will have an important place in securing our future. America has the resources, both intellectual and economic, to champion growth that also respects the environment.

How do the arts play a role? Children engaged in creative activity are stimulating their thinking as well as visual and verbal communication. Their ideas and thoughts move in new directions when they design the future. Children see far more in today's media-saturated world than previous generations did. And those who make sustaining our environment their cause célèbre will need to generate solutions ensuring the information age and technology boom work in concert with nature.

Success begins with each child's love of the outdoors, animals, and our natural resources, a testimonial you'll witness clearly on the next few pages.

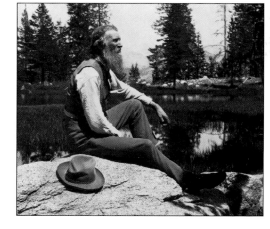

**Naturalist John Muir, considered the father of America's environmental movement, seated on a rock by a lake.**

Aubrey D.
Grade 3
HOMESCHOOL
"Calico Cat"
*I named this picture Calico Cat because of the cat's many colors.*

Abby T.
Grade 1
PLATTIN PRIMARY SCHOOL
"Pattern Cat"
*I made my cat with many patterns and colors.*

Ivy Rose N.
Grade 2
TIMOTHY CHRISTIAN SCHOOL
"The Five Eyed Honey Bee"
*The honey bee collects pollen.*

Geri W.
Grade 5
MILTON ELEMENTARY SCHOOL
"Monkey See Monkey Do"

Dallas D.
Grade 3
MILTON ELEMENTARY SCHOOL
"Under the Sea"
*I like the beach and I used
different shapes and colors
to show life under the sea.*

Giovanny L.
Grade 2
COPPERVIEW ELEMENTARY SCHOOL
"Spider"
*If you look at the spider, it combines
several animals and objects in one.*

Jonah W.
Grade 2
BOYS AND GIRLS CLUB
MUSIC AND ARTS CENTER
"Singing Frog"
*A flying frog that can also sing.*

Crayola *Environment*

Katarina D.
Grade 6
ROSELLE PARK MIDDLE SCHOOL
"The Rose"
*Most flowers come and go so I decided to make one that would last forever!*

Hannah S.
Grade 3
TERRA VISTA ELEMENTARY SCHOOL
"Hummingbirds"
*Ruby-throated hummingbirds with hummingbird feeder and flower.*

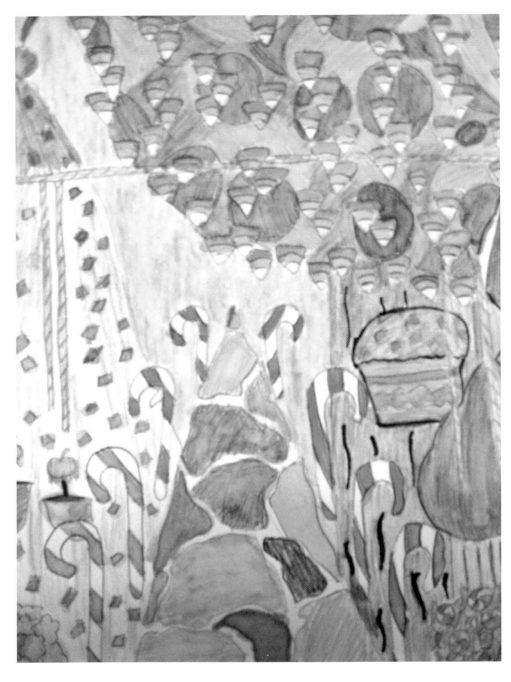

Gabi T.
Grade 4
BOYS AND GIRLS CLUB MUSIC AND ARTS CENTER
"Candy Land"
*Take a walk down Candy Cane lane, experience the sweet sight. With trees of gum drops and candy corn with cupcake bushes around every corner, it's every kids dream.*

Crayola *Environment*

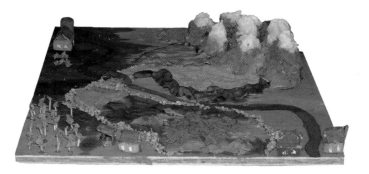

Amber R.
Grade 6
VALLE CATHOLIC GRADE SCHOOL
"Dreamland"
*This is a mixed media with a farmland scene with a lake, river,
mountains, forest, and farmhouse and barn.*

Fiona H.
Kindergarten
LUMEN CHRISTI CATHOLIC SCHOOL
"Pumpkins at the lake"
*Beautiful leaves were falling at the lake around my pumpkin.*

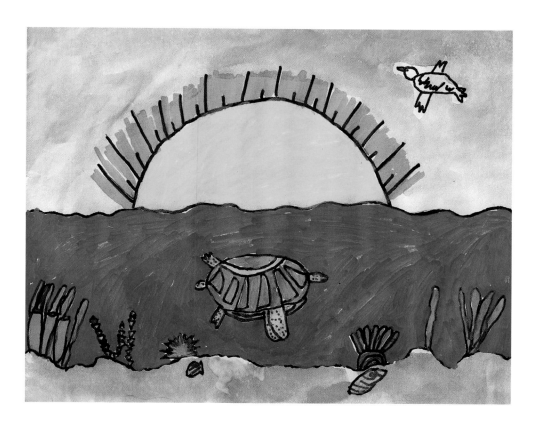

Logan Y.
Grade 5
JOHN STRANGE ELEMENTARY SCHOOL
"Under the Sea"
*I always wanted to visit the beach and wondered what it would
look like. In 3rd grade, my mom and I took a Spring Break vacation
to Florida and I finally got to play in the ocean waves.
It was better than I expected!*

 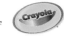

Claudia M.
Grade 6
MITCHELL MIDDLE SCHOOL
"Snail of Rainbows"
*This snail is rare and unique. It fills the world with color by leaving rainbows and color*
*everywhere in its trail, even the ground beneath its feet is filled with colorful designs.*
*That's how the Snail of Rainbows makes sure there's always color and design all around us.*

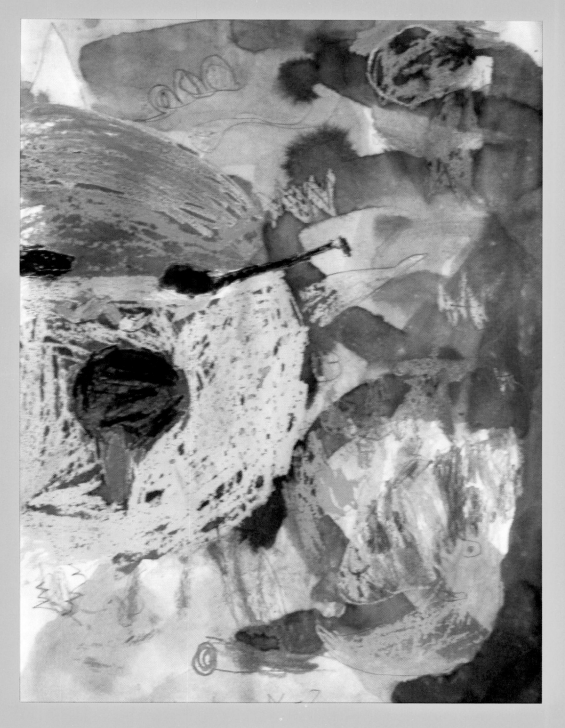

John Michael L.
Grade 2
ARENDELL PARROTT ACADEMY
"Silly Mr. Sun and his friends"
*I had to draw a sun with some emotion. Its called personification.*
*I made mine silly. I put his solar friends with him.*

Marcus B.
Grade 4
SUNSET CANYON ELEMENTARY SCHOOL
"Sailboat in the Ocean"
*In the future, I'd like to go sailing, like this.*

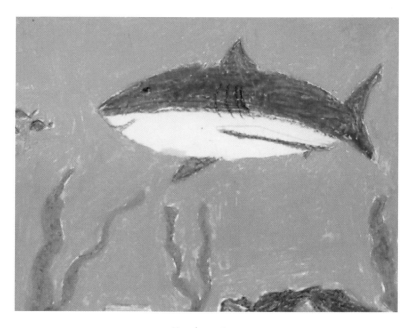

Escher L.
Grade 4
HOMESCHOOL
"Great White"
*I made an underwater scene because 75-percent of the earth is covered by water. I see art underwater because of the different colors, shapes, and sizes of the creatures and plants.*

*"Those who contemplate the beauty of the earth find reserves of strength that will endure as long as life lasts."* — *Rachel Carson*

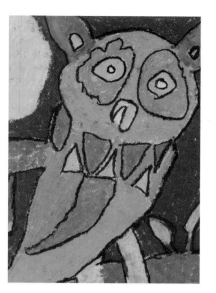

Isaac B.
Grade 3
ROCKY RIDGE ELEMENTARY SCHOOL
"Colorful Owl"
*This owl would brighten up any night with his many colors.*

Taylor B.
Grade 4
BARNARD SCHOOL
"Tree"
*Beauty is all around.*

Zachary B.
Grade 5
ROCKY RIDGE ELEMENTARY SCHOOL
"A Colorful Parrot"
*This is a colorful parrot in a colorful world.*

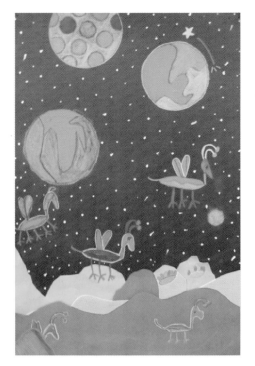

Ellie B.

Grade 4

LINDEN ELEMENTARY SCHOOL

"The Season of Laying Eggs"

*I got my design idea by looking at flying ants. I was trying to imagine them
on a planet completely different from the ones that have already been discovered.*

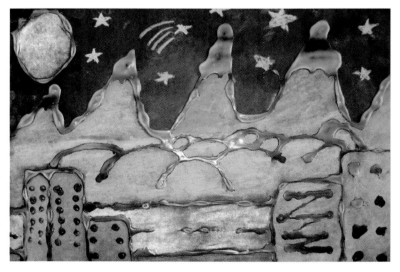

Kirsten W.

Grade 4

ST. STANISLAUS MIDDLE SCHOOL

"Midnight in the City"

*Once there was a quiet city and at night it was even more quiet than the day. It has always been that way but tonight it was different.
It was around 5:00 p.m. and people where just going home. The colorful lights surrounded them while driving. But there was one car that
made a whole bunch of sound. Those sounds made music and changed the black and white lights of the city into color!*

Crayola *Environment*

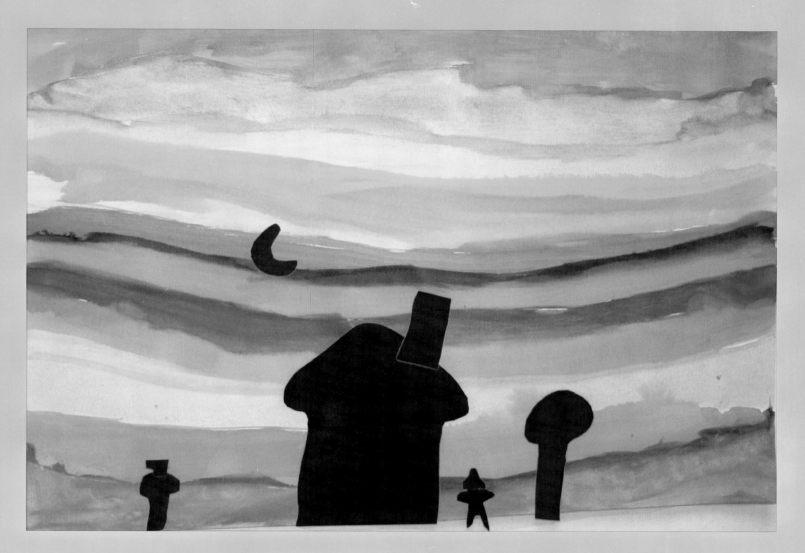

Dreven T.
Grade 2
CHEROKEE ELEMENTARY SCHOOL
"Sunset"
*I felt great about painting my background. The scarecrow is at the bottom of the picture.
The moon is at the top of the sky. The colors make me happy when I look at them.*

# Fashion

*"Style is primarily a matter of instinct." — Bill Blass*

Fashion is the ultimate statement in celebrating and clothing the human spirit. Fashion is emotion. It is motion. It is personal. It is beauty personified. You are what you eat… and wear. Fashion has always been a global business. International designers travel the continents in search of ideas, trends, and fabrics. Fashion innovation makes bold statements—season in and season out.

Fashion can be everyday utilitarian—wash 'n wear, mix 'n match, stiletto pumps, flip-flops, denim jeans, rhinestone jewelry, and hair styles du jour. Fashion can also be high-brow, Rodeo Drive, Fifth Avenue, runway glamour, couture, and elite exclusives.

Visual design is at the heart of fashion. Color creates the mood. Texture and fabric patterns establish the foundation. Accessories and hair styles finish the art form. Models, make-up artists, magazine editors, and typesetters are the unsung heroes—

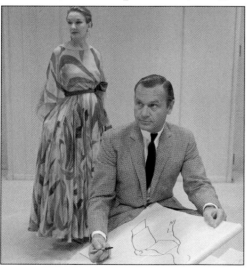

**American Fashion Designer Bill Blass sketches a shape for a dress while a model in one of his creations stands nearby, 1961. The designer offered chic and casual, youthful and glamorous clothes for men and women.**

quietly working behind the scenes, refining their artistic styles. Trends come and go in the fashion industry, but the influence of art is ever present.

Abigail T.
Grade 6
GRUNDY CTR JR SR HIGH SCHOOL
"Same Old Shoe – NOT!"
As you say, "Art is all around us," just like my shoe drawing.
We wear shoes every day, and so I made my shoe into art,
so art really is all around us.

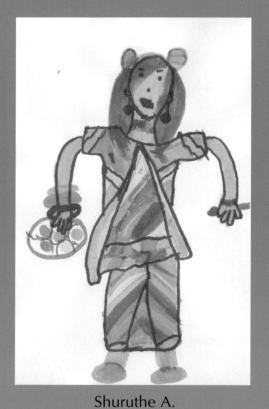

Julia P.
Grade 2
MERITOR ACADEMY
"Wild Life Teacher Costume"
*It is a wild life teacher costume.*

Shuruthe A.
Grade 4
MERITOR ACADEMY
"Art Teacher's Uniform"
*This costume is for the art teacher as a uniform. It can
be turned into a normal dress when you press the red on the pallet.*

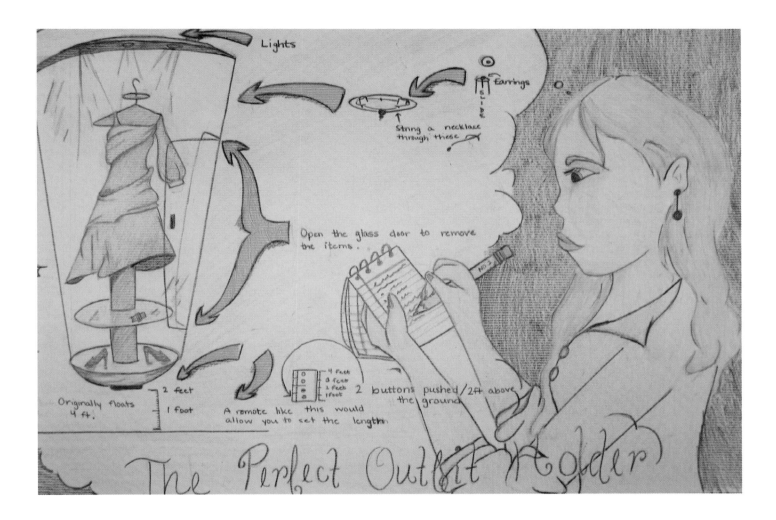

Sarah H.
Grade 5
LIZA JACKSON PREPARATORY SCHOOL
"An Inventor's Future Creation"
*I love fashion, so I chose to show a future designer with her creation*
*of a display wardrobe for her new line of clothing. I enjoy working with*
*colored pencil, it is my favorite medium.*

Kelsey B.
Grade 5
LANSING CHRISTIAN ELEMENTARY SCHOOL
"iPod Flip Flop"
*This is a shoe that plays your personal music anywhere you are!*
*I know tons of my friends would like them as much as I would.*

Carly C.
Grade 3
INMAN PRIMARY SCHOOL
"Party Hat"
*Study of design of hats through art, history and language arts.*

Kaylee C.
Grade 2
FALLON MEMORIAL ELEMENTARY SCHOOL
"My Puppy"
*Pump with puppy face.*

Christian A.
Grade 6
SUNSET RIDGE SCHOOL
"The Kicks"
*They are comfortable and the texture is leather.  It's also basketball shoes
and skateboard shoes together. They are built in heaters
so your feet in cold weather won't freeze.*

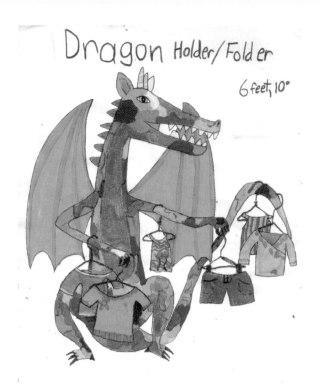

Rowen P.
Grade 5
CORNERSTONE ACADEMY
"Dragon Holder/Folder"
*Wardrobe of the future.*

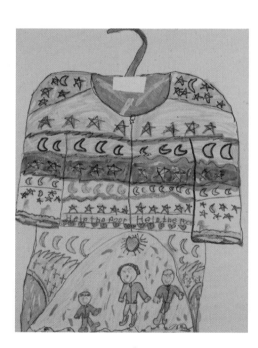

Sarah K.
Grade 2
GUARDIAN ANGELS SCHOOL
"Erase Shivering"
*This family is happy to have the coat I made for them.*

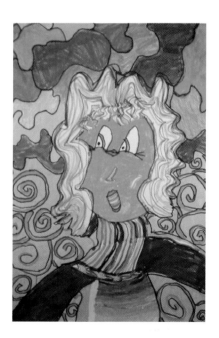

Stella P.
Grade 2
LINDEN ELEMENTARY SCHOOL
"Circus Clown"
*The main idea was to make it something that a clown wouldn't usually be like.*

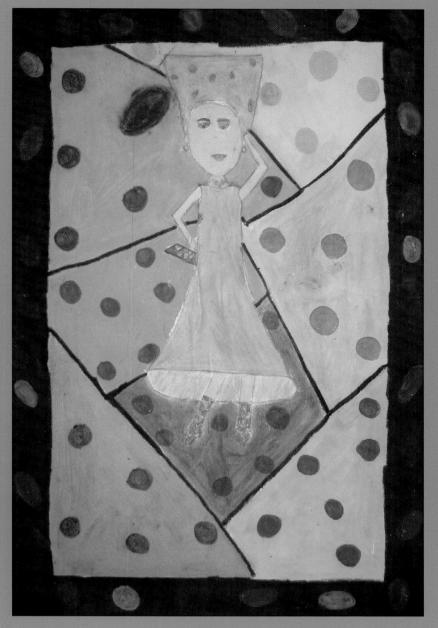

Makenzie K.
Grade 6
ALBERT F. BIELLA ELEMENTARY SCHOOL
"Fashion for the Future"
I believe that in the future science will be much more advanced that scientists will make a way
to use biodegradeable materials to make clothing. If you grow out of your clothes you can bring them
somewhere and they can make new clothes out of your old clothes.

Isabella R.
Grade 6
LARKSPUR ELEMENTARY SCHOOL
"T-shirt Design"
*I designed this to be a very friendly, warm design for a T-shirt for anyone to wear.*

Crayola *Fashion*

Evelyn R.
Grade 5
LARKSPUR ELEMENTARY SCHOOL
"Fabric Design"
*I wanted to create a very modern fabric design, with strong pattern and rhythm.*

# Science & Technology

*"Mystery creates wonder and wonder is the basis of man's desire to understand."*

— *Neil Armstrong*

Necessity is the mother of invention, but it takes imagination combined with knowledge to solve problems. The capacity to innovate requires curiosity and confidence.

The world of scientific knowledge is changing at a rapid rate. Information that students learn today will be obsolete as technology expands our knowledge of the universe. What will remain with students, beyond the lessons and facts of today, are the methods of inquiry and discovery. Creative lessons prepare students for their inquisitive journeys and life-long pursuits of knowledge.

With increasing pressure for academic performance in America's classrooms, creativity is an underutilized resource that can play a much bigger role. When the arts are added to curriculum, test scores improve by 20 percent.[1] When students participate in the arts as an integral part of the curriculum, they are four times more likely to be recognized for academic achievement.[2] Creative thinking is key to academic progress.

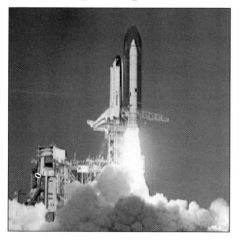

**NASA, established in 1958, has been an important government program reminding Americans of the value of science and technology. Seen here: the launch of the shuttle Discovery in 1984. NASA photo.**

1. Leroux, C. & Grossman, R. (1999, October 21). Arts in the Schools Paint Masterpiece: Higher Scores. Chicago Tribune, p. A-1.
2. National School Board Association.

Turner P.
Kindergarten
VAN R. BUTLER ELEMENTARY SCHOOL
"The Snapping Robotic"
*This is a robot in the future who can snaps his fingers
to make the sun come out.*

Brianna L.
Grade 4
MERITOR ACADEMY
"Hole Digger"
*A fun and comfortable vehicle that digs holes fast so that the family could swim in the future pool on the same day.*

Ansley P.
Grade 1
ROCKY RIDGE ELEMENTARY SCHOOL
"An Artist's World"
*This is what the future of the world looks like to an artist.*

Jessica J.
Grade 5
LEGACY ACADEMY
"Self-Cleaning House"
*I would design a self cleaning house!*

Isabelle M.
Grade 5
ST. MARGARET CATHOLIC SCHOOL
"The Illusion of Time"
*My picture shows the things from the past, present, and what it will be like in the future.*

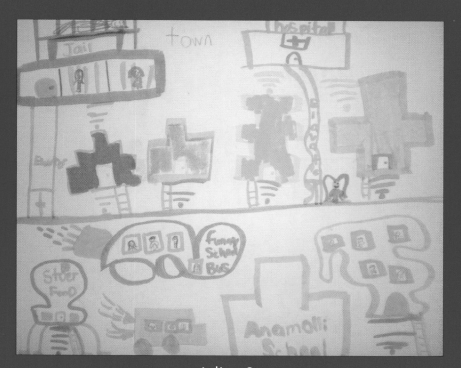

Julian S.
Grade 2
"Town of the Future"
*I drew a town of the future with a school for animals.*

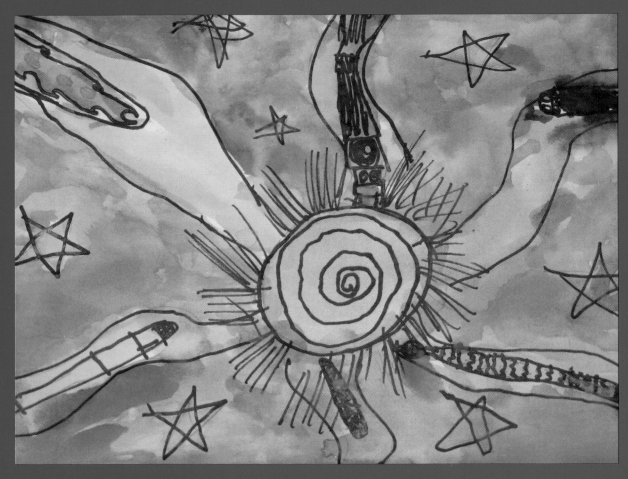

Logan H.
Grade 3
MITTYE P. LOCKE ELEMENTARY SCHOOL
"Hoverboard Massacre"
*I chose this subject because I love hoverboards.*

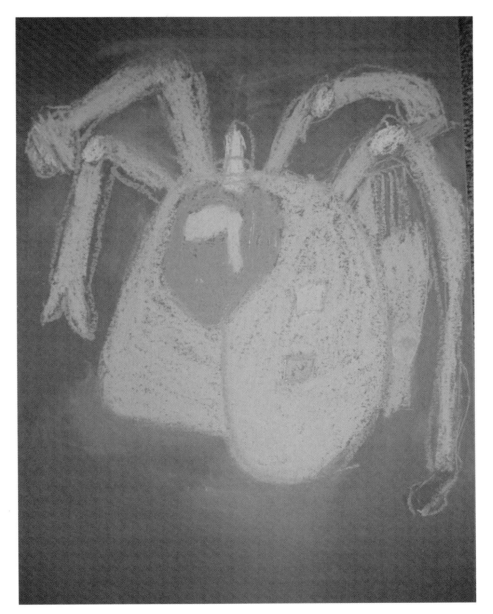

Rebbekkah M.
Grade 6
JEFFERSON ELEMENTARY SCHOOL
"Thinking cap prototype"
*In the future these will be used to aid kids in learning, cleaning houses, doing homework, and almost anything you can dream of.*

John M.
Grade 4
MITTYE P. LOCKE ELEMENTARY SCHOOL
"Flying Cars"
*I believe in the future there will be flying cars.*

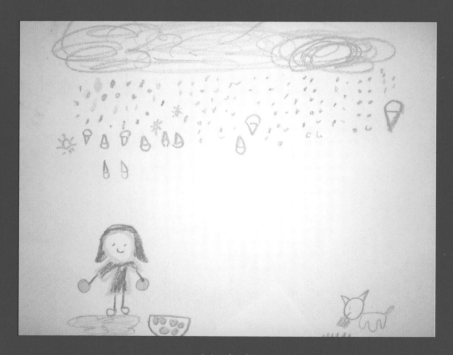

Maria J.
Grade 2
"Weather of the Future"
*My picture of the future is raining jelly beans and ice cream.*

Larenz H.
Grade 5
PS 58
"Robots and Color"
*This is a picture of robots in the future.*

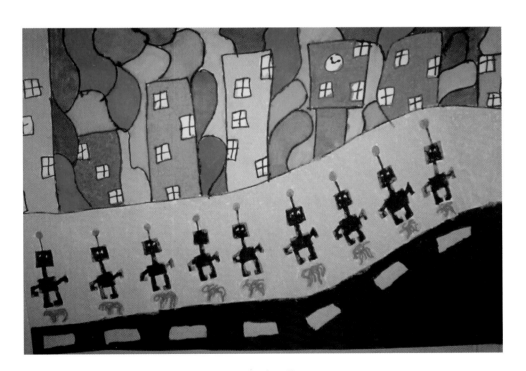

Jazmin G.
Grade 4
PS 58
"Robotic Future"
*This is an art piece of robots in the future city of New York.*

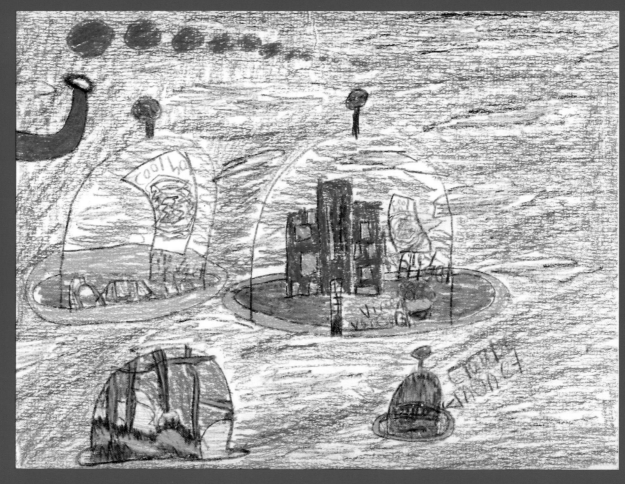

Sierra D.
Grade 3
SPRING LAKE ELEMENTARY SCHOOL
"Sky World"
*Domes float in the sky and have houses that are made out of shapes. Yard decorations by Vincent Van Gogh*
*and Bridget Riley. And two domes are painted as pictures from the past —*
*Claude Monet and Paul Cezanne. There are funny looking phone antennas*
*on three domes. A tube pops out bubbles that people travel in from one place to another.*

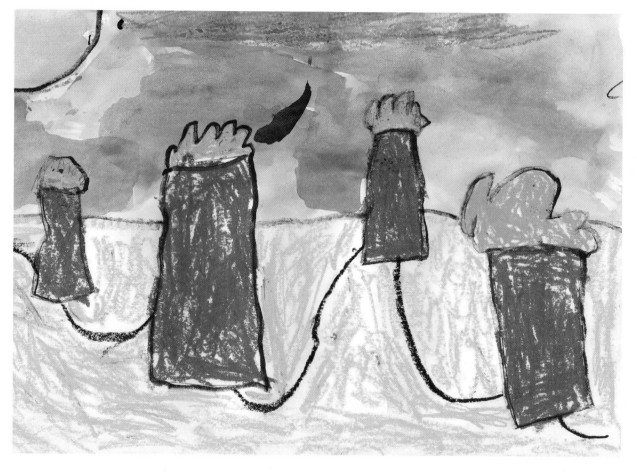

Cody S.
Grade 1
LEGACY ACADEMY
"Electric Trees"
*It's electricity going to all the trees so they can have Christmas lights on all the time.*

Shelbi H.
Grade 5
VAN R. BUTLER ELEMENTARY SCHOOL
"The Bull-Footed Chair"
*This picture shows a futuristic creature called the "Hairbrained That" sitting on a futuristic chair called the Bull-Footed Chair. This Hairbrained That sits on the chair being very kind and sweet.*

Kaytie B.
Grade 1
ROCKY RIDGE ELEMENTARY SCHOOL
"Future World"
*This is my neighborhood in the future. There is a giant robot.*

Cassie R.
Grade 5
VAN R. BUTLER ELEMENTARY SCHOOL
"The Stonewell Flying School"
*The Stonewell Flying School is a school that is in the sky. It has all different kinds of rooms*
*for art, reading, and science. This school is for all kids of all ages.*
*To get to the school they have a flying school bus.*
*The school is all different shapes and sizes, definitely a school of the future!*

# Transportation

*"If you think you can, you can. And if you think you can't, you're right."*
— *Commonly attributed to Henry Ford*

"Beam me up, Scotty" is a phrase from the ultimate frontiersmen on Star Trek; and there are times on our crowded highways and skies that the phrase becomes a wish. Whether we are using planes, trains or automobiles, updated infrastructures are needed to accommodate a growing population. And the need for alternative fuel supplies is imminent. More for less—we need more lanes, more speed, and more miles per gallon, for less cost. All transportation-related professions will need new, innovative employees—including creative thinkers in engineering and design positions. The arts can help connect students' interests to their understanding of the transportation industry. And the arts will contribute to providing the world with new transportation solutions.

Enjoy the clever designs that children have created as they envision transportation of the future. Perhaps you'll see budding vehicle designers or aeronautical engineers in the work featured on the upcoming pages.

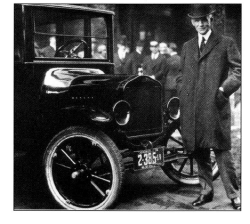

**Henry Ford with his Model T in the early part of the 20th century.**

Ben S.
Grade 4
ST. MARGARET CATHOLIC SCHOOL
"The Next Big Thing"
*This vehicle of the future will make travel very fast and easy!*
*Drivers and passengers will get a new and beautiful view of the world*
*while using the fuel of the future — Kudzu!*

Gage D.
Grade 5
WASHINGTON INTERMEDIATE SCHOOL
"Hot Rod of the Future"
*Vehicle Orange and Green with special wheels designed for the future. Runs on renewable fuels.*

Christian R.
Grade 3
PRESBYTERIAN CHRISTIAN SCHOOL
"Flying Picture"
*The cars walk but the people fly.*

Jenai E.
Grade 3
HOMESCHOOL
"The Flying Bus"
*My picture is about dogs and cats in a bus that flies in the future.*

Maddie C.
Grade 3
LEGACY ACADEMY
"Let's Ski to School"
*I would design a school bus with skis!*
*That way when it snows you can still get to school and not get stuck on the road!*

*"Ballooning is the total absence of sensation, nothing equals the experience. We throw caution to the wind and escape to the sky in an open gondola." — Stan Hess, Hot Air Balloon Pilot*

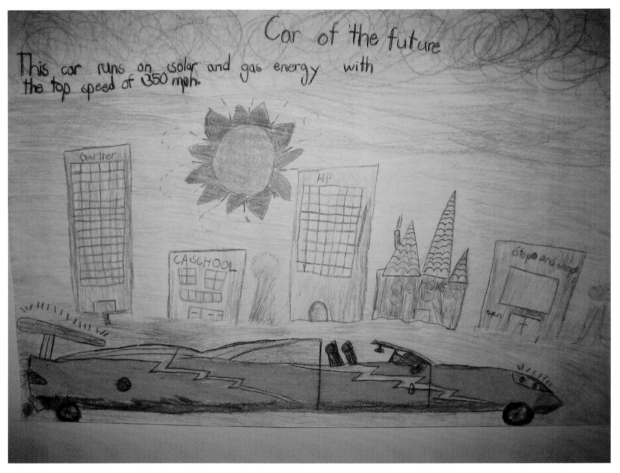

Aman M.
Grade 3
COLEYTOWN ELEMENTARY SCHOOL
"Car of the Future"
*This car runs on solar and gas energy with the top speed of 350 mph.*

Peyton C.
Grade 2
LEGACY ACADEMY
"My Flying Car"
*This is my flying car. I am in it and it has supersonic speed.*

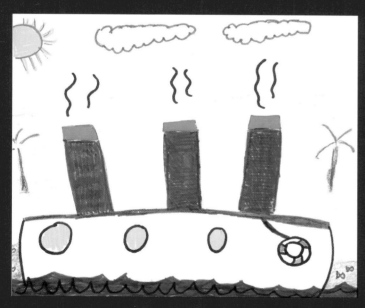

Kassandra G.
Kindergarten
ST. PHILIP OF JESUS SCHOOL
"Fun in the Sun"
*Boat I saw while on vacation. I named it the Titanic.*

Christian C.
Kindergarten
WILLOW SPRING ELEMENTARY SCHOOL
"Hot Mobile"
*Driving in style in a red bad mobile.*

Sarah C.
Kindergarten
ATKINS ELEMENTARY SCHOOL
"Spaceship for the Driver"
*This is a spaceship with a swirl that transforms into a machine that can fix everything
in the spaceship. There are two other spaceships up behind it. There is a gray driver seat
with brown windows. This is what I will drive to work in 30 years.*

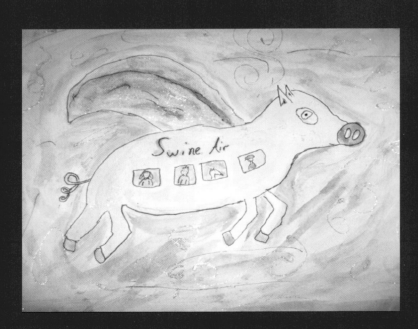

Seth M.
Grade 6
PEACE LUTHERAN SCHOOL
"Swine Air"
*Swine Air is a pig airplane.  Pigs really do fly!*

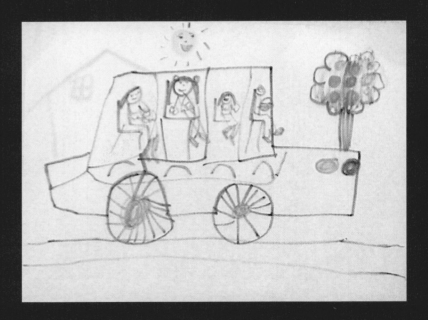

Sujatha V.
Kindergarten
MULTICULTURAL MAGNET SCHOOL
"Car ride"
*My family going on a trip.*

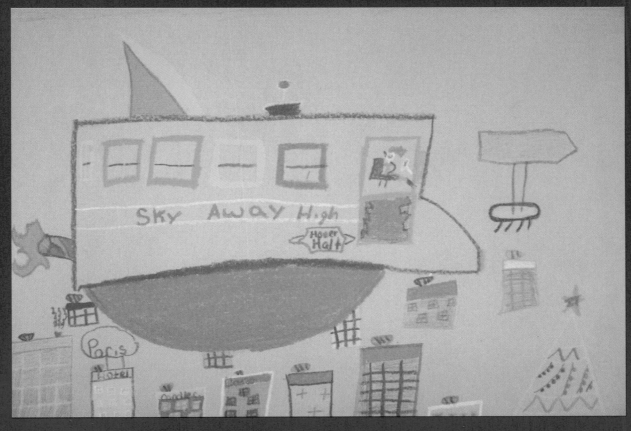

Nicole M.
Grade 4
ATKINS ELEMENTARY SCHOOL
"Sky Away"
My Art work Sky Away High is a future bus twenty years from now. It is flying through the sky
to its far far away school. It has satellite finders, hover discs, and rockets to make it fly like a bullet jet.
This bus also has two radios to entertain us on the ride.

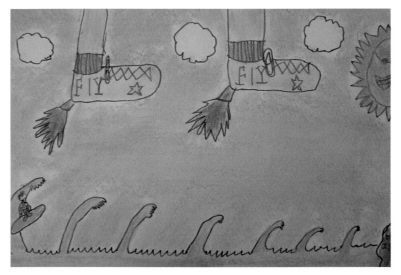

Solanna S.
Grade 4
JOHN TARTAN ELEMENTARY SCHOOL
"Flying Shoes"
*This is about a little kid that wants to go to Hawaii, so he invents flying shoes.*

Lisa S.
Grade 5
CLARKSVILLE ELEMENTARY SCHOOL
"Peek Into Future"
*In the future your can pick any shape cloud, put it in your "air car" and hang it in your room.*

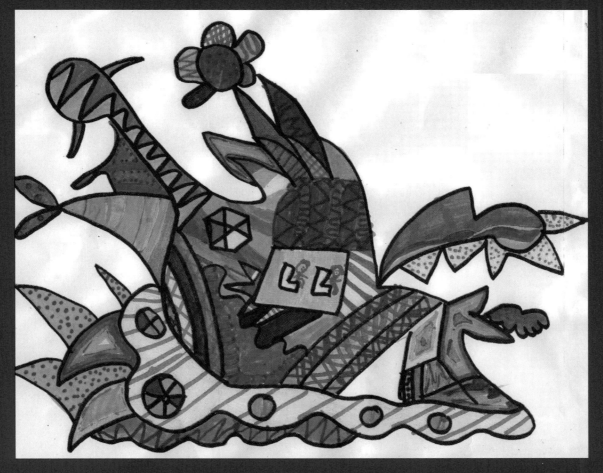

Ritika K.
Grade 3
MERITOR ACADEMY
"Dino Marine"
*It is a vehicle that does any transportation. Boat, Car, Helicopter, etc.*

# 10 Reasons
# Why Art Helps Children Learn

1. Art is a universal language. Communicating visually makes thoughts and feelings come alive.

2. Art builds self-confidence. Children gain a sense of mastery and pride from the completion of a project.

3. Art helps children think independently. Children who are challenged to think of new ideas stretch their minds using imagination.

4. Art integrates learning and improves subject matter knowledge retention. "Doing" creates understanding.

5. Art teaches problem solving. Instead of looking for "one right answer," art helps children generate many original solutions.

6. Art teaches social skills, including collaboration, cooperation, and leadership. Working together fosters positive interpersonal relationships.

7. Art brings aesthetics to our material world. It teaches color, texture, composition, sequence, dimension, as well as understanding of culture, diversity, and perspective.

8. Art helps children make decisions and see possibilities as well as explore other points of view and make the ordinary extraordinary.

9. Art is the foundation for many professions. Try to imagine the world without inventors, designers, entertainers, and artists.

10. Art provides a society with new discoveries and innovations critical to the future success of any nation.

# 10 Ways
# To Creatively Inspire Children

1. **Theme:** Generate a list of topics and use them to spark thinking and action. Serve them to children on a daily or weekly basis and ask them for creative responses.

2. **Pattern:** Teach children how to recognize repetitive, divergent, or congruent patterns that can be observed in nature, art, or physical matter.

3. **Color:** See how colors affect the emotional tone, change the mood of a setting, and influence our lives.

4. **Shape:** Encourage children to identify objects focusing on shapes. Ask them how similarities and differences in form influence what we know about animate and inanimate objects.

5. **Numerical Logic:** Explore the arrangement of objects, components, and ideas. Note how number, size, and flow affect the composition.

6. **Texture:** Encourage children to touch the world around them. Tactile experiences reinforce the visual language they are learning.

7. **Observe:** Challenge children to observe and move beyond the obvious. Ask them to be analytical, perceptive, intuitive, and to share their observations with one another.

8. **Describe:** Language helps children's thoughts move from internal to external. Stimulate the sharing that occurs when children describe their work and what they see around them.

9. **Display:** Build pride and a sense of accomplishment by showcasing children's work.

10. **Reflection:** Understanding increases when we think about what we see. Encourage students to compare and contrast their thoughts on a body of work, and have them look back upon the aesthetic progress of their own art.

**Afterschool Alliance.** A nonprofit organization dedicated to raising awareness of the importance of afterschool programs and advocating for quality, affordable programs for all children. 1616 H St., NW, Washington, DC 20006. (202) 347-1002. http://www.afterschoolalliance.org.

**Americans for the Arts.** 2005. New Harris poll reveals that 93% of Americans believe that the arts are vital to providing a well-rounded education. Press Release available at http://www.americansforthearts.org/news.

**Arts Education Partnership (AEP).** A national coalition of arts, education, business, philanthropic and government organizations that demonstrate and promote the essential role of the arts in the learning and development of every child and in the improvement of America's schools. One Massachusetts Avenue, NW, Suite 700, Washington, DC 20001. http://aep-arts.org.

**Arts Education Partnership.** Edward B. Fiske, ed. 1999. Champions of change: The impact of the arts on learning. Available at http://www.aep-arts.org/publications.

**Arts Education Partnership.** Richard J. Deasy, ed. 2002. Critical links: Learning in the arts and student academic and social development. Available at http://www.aep-arts.org/publications.

**Bromer, G., & Gatto, J.** 1999. Careers in art: An illustrated guide. Second Edition. Worcester, MA: Davis Publications.

**Camilleri, V.** 2007. Healing the inner city child: Creative arts therapies with at-risk youth. Philadelphia, PA: Jessica Kingsley Publishers.

**Crayola.** Thousands of free, standards-based, integrated lesson plans, crafts, and other creative ideas for children, parents, educators, and group leaders are available from the makers of Crayola arts and crafts supplies. 1100 Church Lane, Easton, PA 18044. http://www.Crayola.com.

**De Long, R.**, McCracken, J., & Willett, E. (eds.). 2007. Crayola Dream-Makers: Principles of Art and Design. Easton, PA: Crayola LLC.

**The Foundation Center.** The nation's leading authority on philanthropy, connecting nonprofits, and the grantmakers supporting them, to tools they can use and information they can trust. 79 Fifth Avenue/16th Street, New York, NY 10003. 212-620-4230. http://fdncenter.org.

**Friedman, T**. 2005. The world is flat: A brief history of the twenty-first century. New York: Farrar, Straus, and Giroux.

**Gardner, H.** 1983. Frames of mind: The theory of multiple intelligences. New York: Basic Books.

**Gardner, H.** 1999. Intelligence reframed: Multiple intelligences for the 21st century. New York: Basic Books.

**Gazzaniga, M.** 2005. Arts and Cognition. Progress Report on Brain Research. New York: Dana Press.

**Leroux, C., & Grossman, R.** 1999. "Arts in the schools paint masterpiece: Higher scores." Chicago Tribune, October 21, pp. A-1.

**Lowenfeld, V., & Brittain, W.** 1987. Creative and Mental Growth. Eighth Edition. New York: Macmillan Publishing Company.

**Marzano, R.** 2005. ASCD Report-Preliminary report on the 2004-05 evaluation study of the ASCD program for building academic vocabulary. March, 2005. Association for Supervision and Curriculum Development. Reston, VA.

**National Academy of Sciences,** National Academy of Engineering, and Institute of Medicine. 2007. Rising above the gathering storm: Energizing and employing America for a brighter economic future. Washington, DC: The National Academies Press.

**National AfterSchool Association.** The organization is dedicated to the development, education and care of children and youth during their out-of-school hours. 529 Main Street, Suite 214, Charlestown, MA 02129. 800-617-8242. http://www.naaweb.org.

**The National Art Education Association (NAEA).** Founded in 1947 with the merger of the Western, Pacific, Southeastern, and Eastern Region Art Associations, plus the art department of the National Education Association (NEA). To promote art education through Professional Development, Service, Advancement of Knowledge, and Leadership. NAEA is a non-profit, educational organization. 1916 Association Drive, Reston, VA 20191-1590. 703-860-8000.

**National Assembly of State Arts Agencies (NASAA)** The membership organization that unites, represents and serves the nation's state and jurisdictional arts agencies. 1029 Vermont Avenue, NW, 2nd Floor, Washington, DC 20005. 202-347-6352. http://www.nassa-arts.org.

**National Assembly of State Art Agencies (NASAA)** in collaboration with the Arts Education Partnership. 2006. Critical evidence—How the ARTS benefit student achievement. Washington, DC: Author. (Information missing?) National Association for Music Education (MENC). 2000. Music makes the difference: Music, brain development, and learning. Reston, VA: Author.

**National Center on Education and the Economy.** 2007. Tough choices for tough times: The report of the new commission on the skills of the American workforce. Washington, DC: Author.

**National Institute on Out-of-School Time (NIOST).** For nearly 30 years, the National Institute on Out-of-School Time at Wellesley College has moved the afterschool field forward through its research, education and training, consultation, and field-building. 106 Central Street, Wellesley, MA 02481. 781-283-2547. http://www.niost.org.

**National School Board Association (NSBA).** A not-for-profit federation of state associations of school boards across the United States. Its mission is to foster excellence and equity in public education through school board leadership. 1680 Duke Street, Alexandria, VA 22314. 703-838-6722. http://www.nsba.org.

**New Jersey After 3.** A private, nonprofit organization dedicated to expanding and improving afterschool opportunities for kids. Its vision is for all New Jersey children to have easy access to high quality, comprehensive, structured, supervised, and enriching afterschool activities. 391 George Street, New Brunswick, NJ 08901. 732-246-7933. http://www.njafter3.org

**Partnership for After School Education (PASE).** A New York City-focused organization which promotes and supports quality afterschool programs for youth, particularly those from underserved communities, enabling them to identify and reach their full potential. 120 Broadway, Suite 230, New York, NY 10271. 212-571-2664. http://www.pasesetter.org

**Shaw, G.** 2000. Keeping Mozart in mind. San Diego: Academic Press.

**Smith, M.** 2002. Howard Gardner and multiple intelligences. The encyclopedia of informal education. http://www.infed.org/thinkers/gardner.htm.

**Sylwester, R.** 2000. A biological brain in a cultural classroom. Thousand Oaks, CA: Corwin Press.

**U.S. Department of Education.** The latest information about national educational issues, publications, educational statistics, and information about offices and programs. 1-800-USA-LEARN (1-800-872-5327). http://www.ed.gov.

**Watanabe, D., & Sjolseth, R.** 2006. Lifetime payoffs: The positive effect of the arts on human brain development. Miami, FL: NFAA youngARTS.

**Winner, E., & Hetland, L.** 2007. Art for our sake: School arts classes matter more than ever—but not for the reasons you think. The Boston Globe. September 2, pp. XXXX. (Specify page numbers) http://www.boston.com/news/globe.

# Acknowledgements
# Parents and Educators

**Crayola gratefully acknowledges the parents and educators
who contributed the powerful children's artwork to this book.
We thank you, and all, who continue to support developing the creativity
and imagination of our future generations.**

Pat Agnew-Howe • Janet Applegate • Sara Baird • Marianne Baker • Dotsy Benjamin • Keshma

Benjamin • Jody Berhow • Laurie Burghardt-Noia • Liza Camhi • Naomi Carr • Nora Carter •

Jennifer Cates • Emily Clonts • Jessie Cluck • Becky Combs • Gloria Contreras • Stephanie

Dal Pra • Carrie Davey • Judy Davidson • Lori Dawson • Erin Deasey • Georgia DeFrancisco

• Ann DenHerder • Sharon DiGioia • Dianna Dillon • Elaine DiPofi • Jennifer Espinoza • Pat

Frohman • Kassandra Galvan • Denise Gingold • Leanne Goeschel • Susan Griffin • Lanette

Hauser • Donna Hostettler • Judith Johnson • Sara Johnson • Bo Kim • Joyce Knight-Coyne

• Joan Miller • Manoj Mittal • Laura Moreau • Cathy Myers • Susan Noonan • Jennifer Oien

• Joseph Olah • Rachel Ostvig • Ashley Pearson • Maria Petrovsky • Rebecca Postma • Laura

Powe • Stephen Repasi • Sheila Richey • Constance Rogers • Mishelle Rutledge • Jennifer

Sappington • Kate Schroeck • Lori Schwermer • Patricia Semrick • Marica Shannon • Diane

Sheckells • Carolyn Skeen • Donna Smith • Ellen Soboleva • Ronda Sternhagen • Karla Stille

• Kari Strobel • Brenda Sumner • Kathy Szeliga • Charity Tensel • Lakshmanan Venkatesh •

Lynne Vik • Pamela Weaver • Deborah Welle

# Artists Index